POSTCARD HISTORY SERIES

Stockton

IN VINTAGE POSTCARDS

STOCKTON, THE GATEWAY. This 1930s postcard was published by the Stockton Chamber of Commerce and advertises, "Head of Navigation, where rail and water meet. Four transcontinental railways. Gateway to the San Joaquin Valley, Yosemite, Calaveras Big Trees, Lake Tahoe and Southern Mines. County seat of twelfth county in the United States in crop output. Come look us over."

POSTCARD HISTORY SERIES

Stockton

IN VINTAGE POSTCARDS

Alice van Ommeren

Preserving Stockton's Past

ARCADIA

Published by Arcadia Publishing,
an imprint of Tempus Publishing, Inc.
Charleston SC, Chicago, Portsmouth NH,
San Francisco

Printed in Great Britain.

Library of Congress Catalog Card Number: 2004100473

For all general information contact Arcadia Publishing at:
Telephone 843-853-2070
Fax 843-853-0044
E-Mail sales@arcadiapublishing.com
For customer service and orders:
Toll-Free 1-888-313-2665

Visit us on the internet at http://www.arcadiapublishing.com

STOCKTON, OCTOBER 1849. This postcard shows a watercolor painting by W.H. Creasey for Capt. Charles Weber. The painting represents Stockton in 1849 as the supply base for the southern mines during the height of the Gold Rush. The view from Weber Point shows a tent city, a levee full of supplies, and a slough filled with ships. (Courtesy of the San Joaquin County Historical Society and Museum.)

CONTENTS

Acknowledgments 6

Introduction 7

1. The Waterfront, Riverboats, and Trains 9

2. Landmark Hotels and Popular Cafés 21

3. Prominent Civic and Community Buildings 33

4. Downtown Streets and City Views 47

5. Leading Industries and Commerce 59

6. Rich Farms and Bountiful Harvest 75

7. Renowned Colleges, Schools, and Homes 89

8. Notable Hospitals and Churches 105

9. Famed Mineral Baths, Parks, and Recreation 117

Bibliography 127

Index 128

ACKNOWLEDGMENTS

The local history section of the San Joaquin County Public Library and the exhibits at the Haggin Museum provided me with valuable source material for this book. The Sacramento Public Library and the California State Library were also important resources. Although the dates, names, and places in this book have been thoroughly researched to ensure accuracy, some errors may be possible.

I would like to thank Michael W. Bennett, Debbie Mastel, and Amy Smith of the San Joaquin County Historical Society and Museum for their time and assistance in reviewing the book to ensure historical accuracy. Appreciation also goes to Helen Hutchins and Dorcas Bacigalupi, both long time city residents, for their invaluable insights into Stockton's past.

This project would not have been possible without the assistance of Frances Hutchins who contributed countless hours to the editing and production of this book.

–Alice van Ommeren

INTRODUCTION

The City of Stockton has an illustrious past. At one time, Stockton was a renowned city, famous for its harbor, fine hotels, prodigious agricultural production, and recreational activities. Few remember a time when San Franciscans traveled to Stockton to spend their Sundays at Oak Park or the days when Stockton's famed hot mineral baths drew so many visitors that over 150 dressing rooms were needed. Stockton's Arlington cafeteria, located in downtown Stockton, once served over 1,000 meals a day, and the Hotel Stockton was famous throughout California for its Mission Revival design. Stockton was a major stop on the routes of three transcontinental railways and three trains a day ran between San Francisco and Stockton.

The early 1900s were Stockton's "golden era" and it became one of the most prominent cities in the state. The vintage postcards in this book illustrate Stockton's transformation from a pioneer town to an industrialized city. Founded in 1849 by Capt. Charles Weber after he acquired a 49,000-acre Mexican land grant, Stockton began as a tent settlement and supply center for the southern mines during the California Gold Rush.

After the Gold Rush, the city prospered from its ability to produce grain on a grand scale. The city's major assets were its harbor, strategically located at the head of navigable waterways, and its rich soil and mild climate, making it one of the richest agricultural regions in the nation. The city's waterfront sprouted flour mills, warehouses, and shipping docks in order to supply grain to the markets of the world. With the advent of reclamation and irrigation, Stockton farmers turned to more profitable crops and the city became an industrial center for storing, processing, and shipping. Stockton also became known for innovations and manufacturing of agricultural machinery and for its inland port, which could accommodate oceangoing ships.

Coincidentally, during Stockton's rise to prominence, the use of postcards had become tremendously popular throughout the nation. The first privately printed and mailed postcards were introduced in 1898 when Congress passed the Private Mailing Card Act. Prior to that time only plain government-printed postcards could be mailed. The Act lowered the postal rates on private cards, creating a huge demand for them. Until 1907 the backs of postcards were only allowed to contain the address. During this "undivided back" postcard era, publishers left blank spaces below the pictures on the fronts of cards so that senders could write short personal messages.

In 1907, postal regulations changed and postcards began being printed with "divided backs." This made it possible for both addresses and messages to be written on the back of postcards. As a result, pictures were now able to take up the entire fronts of the cards. With this change, the popularity of postcards soared, ushering in an era referred to by postcard collectors as the

"Golden Age of Postcards." During this era, the majority of postcards were printed in Germany, the leader in lithographic presses.

Another special type of postcard used was the "real photo" postcard. Real photo postcards, also known as mailable photographs, were used as early as 1900. These cards, produced in small quantities by publishers or individuals, were difficult and expensive to produce and are less common.

The advent of World War I caused imports from Germany to decline and the nation's interest in postcards began to wane. Cards continued to be published but the quality plummeted and the demand decreased. Cards printed after 1912 typically have narrow white borders around the pictures. Around 1930, "linen" postcards began being printed on textured paper with a linen-like surface. In 1939, the photochrome postcard, or "chrome," was introduced and is still used today. These cards have glossy finishes and are easily produced using color photography.

Because the golden era of Stockton coincided with the immense popularity of postcards, many aspects of Stockton's celebrated past have been documented for posterity in vintage postcards. The collection of postcards in this book provides views of the city between 1900 and 1950, as well as examples of each of the postcard types mentioned. This book does not give the complete history of Stockton—it only covers the buildings, landmarks, and scenes that were made into postcards. There are many aspects of the city's history that were not shown. For example, Stockton was home to many ethnic communities whose lives were not reflected on postcards.

Nevertheless, the book is a comprehensive illustration of how vintage postcards documented an important period in the history of Stockton. The intent of this book is to provide residents and visitors with a better understanding of and an appreciation for the unique history of this city.

GREETING FROM STOCKTON. This "Private Mailing Card," copyright 1899, is one of the earliest printed picture postcards of Stockton. This postcard provides a rare glimpse of Stockton's Agricultural Pavilion, which opened in 1888 and was the city's largest structure. Covering the entire city block that later became Washington Park, the wooden structure burned down in 1902.

One

THE WATERFRONT, RIVERBOATS, AND TRAINS

270 – WATERFRONT, STOCKTON, CALIFORNIA.

WATER FRONT. The Stockton Harbor, located at the head of the deepwater channel, was the heart of the city. This postcard provides a view of the harbor at the turn of the century. The two tall buildings that stand out on the city skyline are the Masonic Temple to the left and the Courthouse to the right. The postcard predates the Hotel Stockton, which was built in 1910.

THE LEVEE. This postcard of the "Levee" offers an early view of Weber Avenue, facing east. This card, postmarked in 1905, is from the era of "undivided back" postcards, during which the address was the only writing permitted on the back. Notice the delivery wagons parked next to the waterfront sheds. The Sperry Flour Mill buildings stand in the background.

HARBOR. A schooner is docked in this view of the channel east of the Stockton harbor. Schooners were large sailing vessels that could carry huge loads on their decks. Sturdy vessels with flat bottoms had the ability to navigate shallow waters, including Stockton's sloughs. Schooners fell into disuse in the 1930s as shipping goods by trains and trucks became prevalent.

CHANNEL AND SAN JOAQUIN RIVER. This card, postmarked in 1909, offers a view of the head of the Stockton Channel prior to the completion of the Hotel Stockton. A section of the Masonic Temple is visible on the right and Banner Island can be seen in the distance. Notice the railroad tracks running along the waterfront on Weber Avenue and the Sperry Flour Mill in the background on the left.

STOCKTON CHANNEL. This postcard shows steamboats, possibly from an overnight trip to San Francisco, loaded with cargo and passengers docked at the head of the channel. The California Steam Navigation Company, later the California Navigation and Improvement Company (C.N. & I.C.), was organized in 1854. Headquartered across the channel at Weber Avenue and Commerce Street, it monopolized river transportation in Stockton. The Union Transportation Company began in 1892. The two eventually merged to become the California Transportation Company.

Stockton Channel Stockton, Cal.

My boat is running between S. F. and Stockton, temporarily, so I will send you a few views of the Slough City. Yours —

STOCKTON CHANNEL. This "undivided back" postcard sent in 1906 has the following written on the front: "My boat is running between S. F. and Stockton temporarily, so I will send you a few views of the Slough City." This postcard shows the Stockton Channel with a view towards the city. The channel runs three miles west before joining the San Joaquin River.

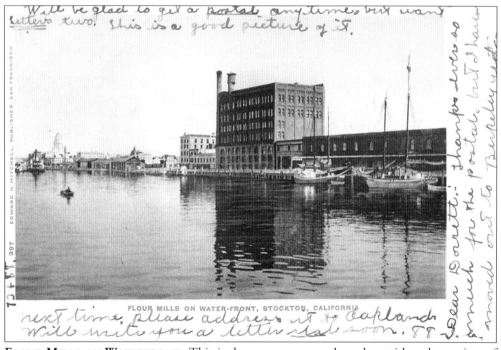

FLOUR MILLS ON WATER-FRONT, STOCKTON, CALIFORNIA

FLOUR MILLS ON WATERFRONT. This is the same scene as above but with a closer view of the channel. Notice the large flour mills and warehouses along the south side of the waterfront. The city was an important milling and transportation center during California's great era of grain trade in the late 1800s.

12

THE PORT. The inland port is located in the heart of the Delta, the richest agricultural area of the world, and is connected to the San Francisco Bay, approximately 70 miles west. This postcard provides an aerial view of the port in the 1930s with the head of the channel and the city in the distance. The slough veering to the left near the head of the channel ends at McLeod Lake.

MCLEOD LAKE, ARK DWELLERS. Houseboats or "arks" built by residents lined both sides of McLeod Lake. The lake was named after Alexander McLeod who led the Hudson Bay Company into this area in the late 1820s. The filling of a large portion of McLeod Lake in 1947 and concerns over public sanitation forced the evacuation of the arks from the lake.

STOCKTON CHANNEL, HEAD OF NAVIGATION. The foreground of this postcard shows bystanders on the El Dorado Bridge, built in 1855, looking westward down the Stockton Channel. The smaller boats on the south bank serviced the farming communities around the city by transporting passengers and freight. The tall buildings in the background belong to the Sperry Flour Mill.

WATER FRONT SCENE. The sender of this postcard writes, "This is another fine city in the west. This is 100 miles from S.F. I came out here on a steamboat. It is a very funny looking river. The boats can't turn around—only in two places, that is, at each end."

WATERFRONT AT STOCKTON. "Two transcontinental railroads and numerous steamship lines served the bustling metropolis of the Upper San Joaquin Valley." The head of the deepwater channel was filled with riverboats carrying freight and passengers between Stockton and San Francisco.

STEAMBOAT RACES ON THE RIVER. In 1939, the city was challenged to two riverboat races by Sacramento. The *Port of Stockton* and *Delta King*, both representing Stockton, won this highly publicized event. Printed on the back of this linen postcard is the following: "Picturesque stern wheelers ply the waters of the Sacramento and San Joaquin Rivers. These rivers provide deep water navigation to the shippers of the rich horticultural and agricultural territory of the San Joaquin and Sacramento Valleys."

Steamer T. C. Walker, Stockton, Calif.

STEAMER *T.C. WALKER*. This 200-foot, 786-ton riverboat was built in 1885 and ran between Stockton and San Francisco until the 1930s. The boat had accommodations for 226 cabin passengers. The first *T.C. Walker* built in 1868 was smaller at 175 tons. The boat was named after an influential riverboat captain who navigated the San Joaquin River. The *T.C. Walker* and the *J.D. Peters*, pictured below, were both operated by the California Navigation and Improvement Company.

STEAMER *J.D. PETERS*. This 880-ton sternwheeler was named after a prominent local grain merchant and built in 1889 at the Jarvis Shipyard in Stockton. For almost 50 years this steamer traveled between Stockton and San Francisco carrying cargo and passengers. It was destroyed in a grass fire in 1965. The steamboats used in the filming of *Steamboat 'Round the Bend* movie included the *T.C. Walker* and the *J.D. Peters*.

943—Santa Fe Depot, Stockton, Cal.

SANTA FE TRAIN DEPOT. The Santa Fe Train Depot on the corner of San Joaquin and Taylor Streets is the oldest railroad station in Stockton and still serves passengers. Built in 1900, it served as the northern terminal of the San Francisco and San Joaquin Valley Railroad, or the "Valley Road." The railroad tracks passed through Fresno and reached to the bottom of the San Joaquin Valley, near Bakersfield.

332 — SANTA FE DEPOT, STOCKTON, CALIFORNIA.

SANTA FE DEPOT. This provides a nice view of the front of the depot, built in a Mission Revival style similar to other stations along the route. In 1900, the Santa Fe operated three trains a day between Stockton and San Francisco. Stockton's Oak Park became a popular resort area for San Franciscans and in 1904, the Santa Fe offered Sunday excursions from San Francisco to Stockton for fares as low as $1 round trip.

SOUTHERN PACIFIC DEPOT WITH CARRIAGES. This postcard of the early 1900s provides a view of carriages pulling away from the train depot on Sacramento Street between Market and Washington Streets. In 1888, the Southern Pacific took over the Central Pacific, which had previously taken over Western Pacific. The Central Pacific had operated the Stockton and Copperopolis Railroad whose tracks ran along Weber Avenue to the waterfront. In 1901, the Weber Avenue rails were removed.

Southern Pacific Depot, Stockton, Cal.

SOUTHERN PACIFIC DEPOT. This postcard from around 1910 shows the second passenger depot of the Southern Pacific in Stockton, located on Sacramento Road between Main Street and Weber Avenue. In 1930, Southern Pacific built a new brick station a block north of the old depot. This building was torn down in the 1950s.

WESTERN PACIFIC DEPOT. In 1909, the Western Pacific was the third railway line to reach Stockton, running from Oakland to Salt Lake City. This passenger depot on Union and Main Street supported the second Western Pacific company until 1970. During that period, Stockton was the only city in California to have three transcontinental railroad connections. The first Western Pacific brought the first locomotive to Stockton in 1869 and was later absorbed by the Central Pacific and Southern Pacific.

The building of this cottage netted the Company over $300

STOCKTON TERMINAL AND EASTERN RAILROAD. In 1910, construction began on an independent railway from Stockton with plans to reach Jenny Lind in Calaveras County. This postcard was used to persuade people to buy shares in the railroad. The railroad's fee for delivering the lumber for building this cottage was used as evidence that the railroad would be a profitable investment. The line never reached Jenny Lind, but terminated in Linden instead.

SOUTHERN PACIFIC MOTOR CARS. These unusual motorcars were built between 1905 and 1920. The wedge-shaped front end design decreased wind resistance and required less power to operate. The rounded windows, resembling ship portholes, were allegedly air and water tight and improved the strength and safety of the car's frame. The "Wind Splitter" was a popular motorcar on the Union Pacific and Southern Pacific Railroads, including the Sacramento, Stockton, Chico, and Fresno line.

CENTRAL CALIFORNIA TRACTION COMPANY. Begun in 1905, this company initially operated a Stockton streetcar line. In 1907, it built an electric railroad from Stockton to Lodi. Another section, running from Lodi to Sacramento over the Mokelumne River, was completed in 1910, connecting Stockton to Sacramento, the state capital. Within Stockton, streetcars were powered by overhead wires. Between cities, power came from a covered third rail carrying high-voltage electricity. Passenger service was discontinued in the early 1930s.

Two
LANDMARK HOTELS
AND CAFÉS

On the road to Yo Semite Valley and Lake Tahoe, Stockton's famous Mission Hotel and Roof Garden.

"THE STOCKTON" WHOSE LONG LINE OF MISSION ARCHES FACES DISTANT MOUNTAINS SET AGAINST A TURQUOISE SKY.

HOTEL STOCKTON, 1920S. The Hotel Stockton was built on El Dorado Street and Weber Avenue, at the head of the Stockton Channel. In the 1800s, the Weber Baths stood on this site. A major attraction for tourism and business, the hotel contributed to commercial development in the city. Notice the old spelling of Yosemite in this 1920s postcard.

HOTEL STOCKTON, 1910s. This postcard shows the city's landmark structure not long after its completion in 1910. The hotel is considered one of California's most outstanding examples of Mission Revival architecture, a style derived from California's Spanish Colonial missions. The five-story building, designed by Edgar Brown, has symmetrical towers and chimneys decorated with domes and arches, a plaster exterior, and red tile roof.

HOTEL STOCKTON ON WATER. This linen postcard shows the hotel with its rooftop sign. The hotel's location near the waterfront provided easy access for travelers arriving from San Francisco, as well as from nearby roads and railways. Several different shops occupy the ground floor under the covered walkway that faces Weber Avenue, including "IXL," a men's clothing store.

2166 – Hotel Stockton, Stockton, California.

HOTEL STOCKTON. The city's landmark structure was built on wooden piles and had 252 rooms, most of them with connecting bathrooms. At the time of the opening the room rates were $1 per day or $2 per day with bath. The hotel was a favorite place for entertainers performing at the nearby Yosemite Theater.

HOTEL STOCKTON. This photo postcard shows the hotel in the 1930s. The second floor served as Stockton's City Hall until 1926. Occupancy began declining in the 1940s with the last guest checking out in 1960. One of the first buildings to be designated a Stockton Historical Landmark, it was placed on the National Register of Historic Places in 1981. The hotel is currently being developed for stores, restaurants, and apartments.

23

LOBBY, HOTEL STOCKTON. The spacious interior lobby was one of the Hotel Stockton's most distinctive features. This postcard provides a view of the large concrete fireplace with "Indian Motif" decorative tiles. The hotel's grand lobby was adorned with Native American artifacts for many years.

GRILL, HOTEL STOCKTON. Postmarked in 1911, this postcard offers a view of the famous "Grill" restaurant. It was located on the ground floor of the Hotel Stockton and adjoined the main dining room.

1686- Roof Garden, Stockton Hotel, Stockton, California

ROOF GARDEN, HOTEL STOCKTON. A distinctive feature of the Hotel Stockton was the roof garden that opened several years after the completion of the building. The garden pavilion, located on the west side of the roof, featured a central fountain surrounded by tropical plants and pergolas at each corner. The overhead trelliswork was covered with roses and other vines.

1692- Roof Garden, overlooking Channel, Hotel Stockton, Stockton, California.

ROOF GARDEN, HOTEL STOCKTON. Although occasionally used for dining, the roof garden pavilion was more commonly used for dancing. Guests could sit in the roof garden and watch the sun set over the Stockton Channel with Mount Diablo on the horizon. Screens provided protection from the wind. In the 1950s, streetlights and radio antennas were mounted on the roof.

25

HOTEL CLARK. Along with the Hotel Stockton and the Hotel Wolf, Hotel Clark was considered to be one of the top three hotels in Stockton during the 1920s. This five-story brick building was completed in 1911 on the southeast corner of Market and Sutter Streets. The hotel's dining room and ballroom opened a few years later and hosted dinner dances on Friday, Saturday, and Sunday nights.

HOTEL CLARK WITH SHOPS. Over the years, many of the larger hotels in Stockton, including the Hotel Clark, were converted into inexpensive apartment houses.

IMPERIAL HOTEL. Considered the city's finest hotel until 1910, the Imperial was built by the Rothenbush family, owners of the El Dorado Brewery. Built in 1898 at Aurora and Main Streets, it was the first hotel to have hot and cold water in each of its 55 guest rooms. The roof tower provided guests with a view of the city. The upper floors were eventually removed, but the main floor still stands.

LOBBY, HOTEL WOLF, STOCKTON, CALIFORNIA

HOTEL WOLF. This postcard shows the lobby of the five-story Hotel Wolf, which opened in 1925 at 409 East Market Street. A postcard advertises it as "A convenient place to stop on the Golden State Highway. A starting place for Yosemite Valley or other Mother Lode, district of California, in the heart of The Delta region."

HOTEL WOLF, 1937. This postcard, mailed in 1937, is a view of the intersection of Market Street and California Street, facing west. The Hotel Wolf is seen on the right. The handwritten message on the back reads, "We are attending a very lovely convention in a very lovely city. There was 29 comrades of G.A.R. at the banquet last eve—hope you are better—love."

HOTEL ARLINGTON. This postcard provides a view of the lobby of the Hotel Arlington. The hotel opened in 1910 on Sutter between Main and Market Streets. The owner of this hotel, F.A. Parker, also owned the adjoining cafeteria but sold it the following year.

ARGONAUT HOTEL. This view faces east on Weber Avenue at the intersection of Hunter Street. The tall building on the left is the Tretheway Building, built in 1892 as the Argonaut Hotel and still standing today. The Hammond and Yardley Grocery Store is located to the right. This store operated at this location since the 1870s and provided groceries and hardware.

Hotel St. Leo, Stockton, Calif.

HOTEL ST. LEO. This hotel was constructed on the corner of California Street and Weber Avenue in 1913. Central Drug Company occupied the ground floor. The hotel closed for business in the 1930s, but the building still stands today.

LINCOLN HOTEL. Stockton once was home to the third largest Chinese community in California. The Wong Brothers built this five-story fireproof building at 120 South El Dorado Street in 1919. Considered one of the first-class hotels in Stockton and the pride of Chinatown, the hotel hosted dinner dances and concerts on Saturday and Sunday nights. The Lincoln had a decorative interior, spacious lobby, and basement parking. It was torn down in the 1960s.

HOTEL ARLINGTON CAFETERIA. In 1911, Henry Burke opened the Arlington Cafeteria located next to the Hotel Arlington on Sutter Street. Serving over 1,000 meals a day, the cafeteria became known throughout the Central Valley as the "House of Good Eats." The prosperous business served three meals a day and the cafeteria space had to be enlarged several times over the years. At one time, it employed more than 50 people.

LONJERS CAFÉ. In 1907, Henry Lonjers opened the Club Saloon or Lonjers Café at 14 North Sutter Street. In 1910, the city listed 106 saloons in operation. In 1918, Prohibition made it illegal to sell or serve liquor, forcing the closure of many saloons. Lonjer turned to serving soft drinks for a couple of years before closing at this location. Notice the animals on display.

YE OLDE HOOSIER INN. This restaurant began in 1933 as a trucker's café. The Dyer family purchased the restaurant in 1946 and named it the Hoosier Café. Several years later it was expanded and renamed Ye Olde Hoosier Inn. Since that time the ownership has changed, but the restaurant remains today.

YE OLDE HOOSIER INN. This postcard shows the Red Parlor Room, the waiting room for the restaurant. The interior of the restaurant was decorated with rare and beautiful antiques to provide "Old Time Atmosphere." The rafters in the dining room were decorated with scriptures.

Three
PROMINENT CIVIC AND COMMUNITY BUILDINGS

372 — COURT HOUSE, STOCKTON, CALIFORNIA.

SAN JOAQUIN COUNTY COURTHOUSE. This postcard pictures the second county courthouse, built in 1890. It replaced the original courthouse, built in 1853. Capt. Charles Weber donated land for the courthouse in 1850. Concerned that the property was located between two sloughs, he required that a slough west of the block be filled in, creating the plaza named Hunter Square. The small structure on the far right of the postcard is a granite drinking fountain.

VIEWS OF THE COURT HOUSE. This unique fold-out card (*above*) provides a panoramic view of the courthouse and Hunter Square in the early 1900s. The water wagon parked in front of the courthouse was used to keep dust down on the unpaved streets. Broad expanses of lawn,

372 – Court House, Stockton, California.

palm trees, and diagonal walkways surrounded the courthouse. At the left is Mansion House with Lambert's Cigar Factory and a view down Weber Avenue. To the right are Odd Fellows Hall and other businesses facing Hunter Square.

SAN JOAQUIN COUNTY COURTHOUSE. The courthouse was built with locally made brick and with granite similar to that used to build the state capitol in Sacramento. The building had four entrances and the interior included two wide stairways that extended to the third floor. These flights of stairs originated at the north and south side of the first floor. This three-story courthouse was once regarded the finest in the state.

SAN JOAQUIN COUNTY COURTHOUSE. The back of the postcard reads, "Everything was on the grand scale. Columns were immense, hallways spacious, ceiling high and lighted by the latest in gas lamps. Woodwork was intricate and fine mahogany and walnut hardwoods. The floor tile was imported from Belgium, its pattern reflecting the Byzantine period." Two cannons, presumed to have been used by Comm. F. Stockton in his conquest of California, were displayed outside.

SAN JOAQUIN COUNTY COURTHOUSE. A 12-foot-tall statue of Justice was placed on top of the courthouse dome in 1890. The gilded zinc statue weighed 500 pounds. This courthouse building was occupied by the city until 1910 and by the county until 1930. Beginning to deteriorate, the building was demolished in 1961 to make room for the current courthouse. The Goddess of Justice is now displayed at the west entrance of the present courthouse.

North San Joaquin St., cor. Channel St., Stockton, Cal.

SAN JOAQUIN COUNTY JAIL. This 1907 card shows the corner of San Joaquin and Channel Streets looking northward, with the county jail to the right. The three-story jail was completed in 1893 to hold 75 prisoners and was referred to as "Cunningham's Castle" after Sheriff Thomas Cunningham. The Emergency Hospital is located next to the jail. The Western School of Commerce is on the left and Central Methodist Church is in the distance.

ARCHITECTURE, SAN JOAQUIN COUNTY JAIL. This card depicts the unique Richardsonian architectural style of the jail, used to create a sense of massiveness. Characteristics of this style include round or square towers, short robust columns with decorated capitals, contrasting stone colors, and rock-faced masonry. Although the outside of the jail was appealing, the inside was dark and dreary. The jail was abandoned in 1959 because of overcrowding and lack of sanitary conditions.

CIVIC CENTER. This 1940s postcard provides an aerial view of McLeod Lake when it still extended to El Dorado Street. At left is the Civic Memorial Auditorium and to the right is City Hall. Above City Hall is a square block once occupied by the Pacific Tannery, a major industry from 1865 to 1926 that shipped leather goods all over the world. Much of McLeod Lake was filled around 1947.

REGATTA SCENE. This postcard depicts recreational boats anchored in McLeod Lake during a Stockton regatta. The *Peggy B*, a 43-foot cruiser in front of the Civic Memorial Auditorium, is typical of boats built by Stephens Brothers during the 1930s. The lake extended to the north of City Hall, now Martin Luther King Junior Plaza. Steamers would often back into McLeod Lake to turn around before heading back down the channel.

CITY HALL, NORTH SIDE. This postcard shows the north side of City Hall soon after its 1926 dedication. A plaque on City Hall states, "Site of the first building in Stockton. In August 1844, the first settlers arrived at Rancho Del Campo de Los Franceses. One of the company, Thomas Lindsay, built the first dwelling, a tule hut, on this site. He was later murdered by Indians and buried here by travelers."

CITY HALL, SOUTH SIDE. This 1940s postcard shows the south side of City Hall. Both City Hall and the Civic Auditorium were built during the "City Beautiful Movement" of the 1920s. Old cobblestones, reclaimed from city streets, were used to pave the parking lot. The wooden flag pole dates to 1915 and was originally located at the California Navigation and Improvement Company, a major sternwheel riverboat operator.

CIVIC MEMORIAL AUDITORIUM, SIDE VIEW. This Classic-style structure, located at Center and Oak Streets, was dedicated in 1926 as a memorial to Stockton soldiers killed in World War I. Bronze tablets inscribed with the names of soldiers lost in combat are displayed in the lobby. Six Roman Doric columns decorate the front of the building. Above each entrance are sculptured panels with the seals of federal, state, and city governments and several veterans' organizations.

CIVIC MEMORIAL AUDITORIUM, FRONT VIEW. This two-story structure faces Martin Luther King Junior Plaza and is located near City Hall and the public library. The lobby of the auditorium opens into a circular arena surrounded by a balcony and a main stage with a proscenium arch. The ceiling is a flat dome with a large glass skylight. Surrounded by smaller meeting and lecture rooms, the main auditorium seats 5,000 persons.

"OLD" POST OFFICE. The Stockton Post Office was established in 1849 to deliver mail to mining camps. Homes and business did not have mail delivery until the 1890s. This postcard shows the first government-owned post office built in 1902 at Market and California Streets. This two-story sandstone building was the main post office for more than 30 years. After the post office relocated, it was used as the city's Hall of Records before being demolished in 1965.

"NEW" POST OFFICE. Since 1933, the post office and federal offices have occupied this building at San Joaquin and Lindsay Streets. This two-story block structure was built in the Classic architectural style typical of federal buildings in the 1920s and 1930s. Architectural characteristics include the raised foundation base, stonewalls, colonnades, and the stepped railing cap. This building was built by the WPA (Works Progress Administration) that employed out-of-work laborers during the Depression.

Hazelton Public Library, Stockton, California. 2101

HAZELTON LIBRARY. The first public library was funded by Dr. William Hazelton and built in 1895 on the northeast corner of Market and Hunter Streets. Covered in white marble, this building housed the library for almost 70 years and was demolished in 1964. Its marble Ionic columns were relocated to the University of the Pacific. On the left is Hunter Street Fire House, topped by a bell and clock from the first courthouse.

STOCKTON FIRE DEPARTMENT. In 1849, the Weber Bucket Brigade became the first of many fire companies in Stockton. In 1888, the volunteer companies were replaced by a paid fire department. Fires have destroyed many significant buildings in Stockton and contributed to the loss of many lives. This real photo postcard shows one of several fire trucks used by the Stockton Fire Department in the early 1920s.

HAGGIN MEMORIAL ART GALLERY AND MUSEUM, FRONT VIEW. The Haggin Museum was built in 1931 with financial support from the San Joaquin Pioneer and Historical Society and from Robert and Eila Haggin McKee. The three-story natural brick building with Corinthian pillars is located in the middle of Victory Park on Pershing Avenue. The private nonprofit institution is named after Louis Terah Haggin, an attorney who donated his art collection to the museum.

HAGGIN MEMORIAL ART GALLERY AND MUSEUM, SIDE VIEW. The Haggin Museum was originally named the Louis Terah Haggin Memorial Galleries and the San Joaquin Pioneer and Historical Museum. Besides its fine art collection, the museum has several areas dedicated to local history. The Pioneer Room provides a chronological tour of Stockton's past and the basement level provides a replica of the city in the late 1800s. In 1981, its name was changed to the Haggin Museum.

ELKS BUILDING. Located at Sutter Street and Weber Avenue, this Classical-style five-story building was built in 1909. The first floor was built of concrete and the upper stories of brick. The top floor was a meeting hall with a beautiful stained-glass dome, originally intended for the San Francisco Elks Lodge, but relocated to Stockton after the 1909 earthquake. The building remains today, although a fire destroyed the meeting hall in 1980.

PHILOMATHEAN CLUB. Constructed for a private women's club in 1912, this rustic Craftsman-style building was designed by local architect W.E. Wood. The club was named Philomathean, meaning "lover of learning." Located at Acacia and Hunter Streets, the two-story building includes decorative stained glass, a large entry hall and staircase, a second-floor ballroom, and a large outdoor porch. Currently within the Magnolia Historic Preservation District, the building is now owned by the city.

ODD FELLOWS HALL. The Odd Fellows fraternal organization was formed in Stockton in 1852. This card, postmarked in 1910, pictures their three-story building, constructed in 1866 on the corner of Hunter and Main Streets. The top two floors were used for club activities and the ground floor was rented to businesses. This was the club headquarters until 1920. The Hunter Street Fire House, with the bell and clock from the first courthouse, is to the right of the hall.

Four
DOWNTOWN STREETS
AND CITY VIEWS

MAIN STREET, LOOKING EAST. This postcard shows the corner of Main Street and El Dorado Street, looking east down Main Street, the major thoroughfare of the city. This view shows part of the courthouse on the left and the Stockton Savings and Loan building on the corner of San Joaquin Street. The trolley traversed Main Street, from east to west.

MAIN STREET, LOOKING EAST. This card, postmarked in 1908, provides a view of Main Street looking east from Center Street. On the left side of the street up a block is the "IXL," a men's clothing store operating on the corner of El Dorado Street and Main Street since 1884. In 1910, the clothing store moved into the ground floor of the Hotel Stockton building.

UPPER MAIN STREET. This postcard shows the 500 block of Main Street *c.* 1910. On the left is the Sherman Clay and Company Pianos who, according to their advertisements, sold "pianos, talking machines and music." Note the horse-drawn buggy and bicycles parked along the street.

MAIN STREET FROM HUNTER SQUARE. This postcard sent in 1913 shows a view looking east at the Odd Fellows building on the corner of Main Street and Hunter Street. A portion of the courthouse square is visible on the left. The Stockton Savings and Loan building is on the far left.

MAIN STREET, LOOKING EAST FROM HUNTER SQUARE. This is a similar view to the previous card, except that this postcard is *c.* 1920. Note that the Farmers and Merchants Bank has been erected at the southwest corner of Main and San Joaquin Streets. The preponderance of streetcars and automobiles along Main Street shows the popularity of downtown Stockton in the 1920s.

MAIN STREET, LOOKING EAST. This card, postmarked in 1914, is another view of Main Street looking east. Hale's Dry Goods is at the corner of San Joaquin Street on the right and the Stockton Savings and Loan building is on the left corner.

MAIN STREET, LOOKING WEST. This view from the 1920s is of the intersection of Main Street and California Street, looking west. On the right is the store of Henry J. Kuechler (also pictured on page 65). The towering building in the background is the Commercial Savings Bank.

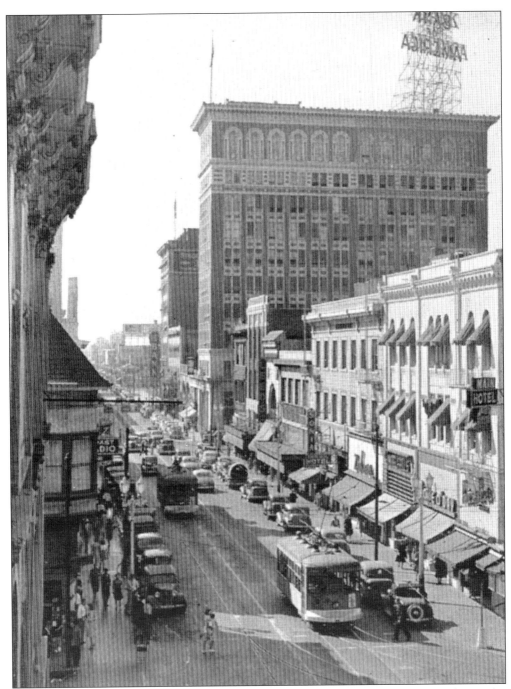

MAIN STREET, LOOKING WEST. This card is a similar view as the postcards on the previous page, but this postcard probably dates from the 1940s. It says, "Stockton's main street in the downtown shopping district. This serves a metropolitan population of over 70,000 inhabitants." Until the 1950s, the city's leading shops were located on Main Street and Weber Avenue. That changed in the 1960s when substantial residential and commercial growth occurred north of the Calaveras River.

VIEW FROM COURTHOUSE. This 1909 postcard shows a great view of Weber Avenue looking towards the Stockton Channel. The courthouse and Hunter Square are on the left. Along Weber Avenue on the right is the Hammond & Yardley Grocery Store, the Tretheway Building and Mansion House, with the old Masonic Temple behind it. The Hotel Stockton was not built until 1910.

WEBER AVENUE, LOOKING EAST. This postcard shows the Hubbard building on the corner of San Joaquin Street and Weber Avenue, looking east down the avenue. Notice the electrical wires that powered the trolleys in town.

East Weber Street, looking East, Stockton, California.

WEBER STREET, LOOKING EAST. This postcard is a similar view as the previous postcard, but is *c.* 1920. The corner of the Hotel Stockton is visible on the left and an edge of the courthouse can be seen on the right. Weber Avenue was named by the citizens of Stockton in honor of the city's founder, Capt. Charles Weber.

WEBER STREET, LOOKING EAST. This postcard provides a view of Weber Avenue around 1940. This view also faces east, but shows the intersection of Weber Avenue and San Joaquin Street. The Belding building can be seen on the left corner. Notice the change in height of the palm trees on the courthouse square from the previous postcard.

HUBBARD AND YOSEMITE BUILDINGS. The Hubbard building at the corner of San Joaquin and Weber Avenue is pictured on the left. Next to the Hubbard building is the Yosemite Theater, a very popular venue that attracted many famous entertainers to town. This postcard also shows the Central California Traction Company streetcar, which began operating an electric street car system in Stockton in 1906.

SAN JOAQUIN STREET. This postcard shows the Farmers and Merchants Bank at the corner of San Joaquin and Main Streets. In this view, facing south on San Joaquin Street, the courthouse square is visible on the right.

SUTTER STREET, LOOKING NORTH. Several historic buildings are shown in this view of downtown in the 1920s taken on Sutter Street. The Hotel Clark appears on the immediate right. The Hotel Arlington is further down the street. The ten-story building in the back is the Commercial and Savings Bank.

MARKET STREET, LOOKING EAST. This is a "real photo" postcard of Market Street in the late 1940s. This view faces east from the corner of Sutter Street. The Hotel Wolf is the large building in the center of the postcard.

EL DORADO STREET. This postcard shows the intersection of El Dorado Street and Harding Way, facing north. In the early 1890s, horse-drawn cars were replaced by electric streetcars. This particular electric street car, or trolley, originally ran north and south along El Dorado Street from Main Street to Harding Way. In 1912, the route was extended from Harding Way to Oak Park. Notice the Hillman residence on the left.

Palm Avenue, Stockton, Cal.

PALM AVENUE. This postcard, sent in 1907, shows Palm Avenue, located north of the State Hospital grounds. The street is lined with California Fan Palms, the only palm native to western North America. The buggy, a four-wheel carriage with a two-passenger seat, is being drawn by a horse.

PACIFIC AVENUE, FORMERLY SACRAMENTO BOULEVARD. This real photo postcard is a view of Pacific Avenue looking south. The avenue became prominent during the 1940s as Stockton's first shopping area built north of downtown. Pacific Avenue, which headed north from the downtown area, was originally named Sacramento Boulevard.

PACIFIC AVENUE. This postcard mailed in 1941 is a view of Pacific Avenue facing north. The printing on the back proclaims the avenue to be, "One of Stockton's newest and finest shopping districts." The shopping area is often referred to as the "Miracle Mile."

A RESIDENT STREET SCENE. The land the city of Stockton was built upon was once covered with an impressive oak forest. Many trees were cleared to provide room for the settlement and its streets. Some old trees have been preserved.

One of the many beautiful Streets of Stockton, Cal.

THE BEAUTIFUL STREETS. Stockton gained a reputation for having one of the best shaded residential areas in California with an abundance of oak, elm, maple, and acacia trees. Capt. Charles Weber named many streets after plant and flowers. The streets north of Fremont Street are named Oak, Park, Flora, Poplar, Acacia, Magnolia, Vine, and Willow.

Five
LEADING INDUSTRIES
AND COMMERCE

Stockton Harbor, Stockton, San Joaquin Co., Cal.

STOCKTON HARBOR. The city's rapid growth during the early 1900s created a demand for large quantities of lumber. By 1907, 30 million feet of lumber were delivered to the city annually by shallow river boats. This postcard shows river schooners on the south bank of the channel delivering timber products. The freight sheds and cars were used for storing and hauling these building supplies.

CARPENTERS. This postcard, mailed in 1909, shows a group of carpenters posing for the Local 78 Carpenters' Union. At the time, carpenters were paid approximately $4 a day. Carpenters' unions had existed since the 1880s. The growth and development of the city at the beginning of the 20th century created a great demand for laborers and tradesman.

PACIFIC WINDOW GLASS COMPANY. This 1902 glass factory was the first to be built west of the Mississippi. The "glass sand," comprised of 75 percent quartz and 25 percent clay, was mined in Tesla, a town near Livermore. The sand was transported by railroad to the factory located on South Hunter Street, now McKinley Park. The company became vitally important when the 1906 San Francisco earthquake created a great demand for glass.

HOLT MANUFACTURING COMPANY. Located at the center of the grain production in California, Stockton was well situated for the manufacturing of agricultural machines. Although a number of local companies pioneered in the fabrication of various types of equipment, the most famous was the Holt Manufacturing Company. This postcard shows one of their traction engines. The company developed the Caterpillar tractor in 1906 and continued to contribute to mechanical and engineering advancements.

WESTERN HARVESTER COMPANY. This Holt Manufacturing Company plant was located at the corner of Aurora and Church Streets. Established in 1883, the Holt Company rose to fame under the leadership of Benjamin Holt. By the early 1900s, the plant covered 15 acres, employed 4,000 people, and shipped machines all over the world. It merged with the Best Tractor Company in 1925 and became known as the Caterpillar Tractor Company. The Stockton plant closed in 1929.

PORT OF STOCKTON FROM THE AIR. In 1933, Stockton became California's first inland port. This view of the Port of Stockton *c.* 1940 was captured prior to the building of grain elevators in 1955. The back of the postcard reads "The Port of Stockton, California's only inland deep water port, 88 miles inland from the Golden Gate, serves the agricultural empire of northern and central California with shipping to and from the Ports of the seven seas."

PORT OF STOCKTON. Due to its deep and wide waterways, the port was able to accommodate large ocean-going ships. This led to the development of additional wharves, transit sheds, warehouses, and grain terminals during the 1930s and 1940s, making the port a center of agricultural and industrial trade. In 1944, a naval supply depot was built next to the port on Rough and Ready Island to support the military effort during World War II.

THE LUCKENBACH. This 1950s postcard shows the ship Lukenbach being loaded with cotton. The back of the postcard states, "Cotton, California's number one field crop, at the Port of Stockton on its way to market. California ranks fourth in the production of cotton and has the highest yield per acre of any state. Practically all of the present cotton acreage is in the San Joaquin Valley."

BOATBUILDING. Shipbuilding was a major Stockton industry until 1950. Beginning with the construction of sloops, shipbuilders also made riverboats, steamers, barges, dredges, and eventually ships for World War II. This "chrome" postcard reads, "One of the many boat-building concerns on the channel. Stockton shipworks engage in building mine sweepers as well repair and overhaul patrol and crash boats for the navy and air force under government contracts."

CUNEO MARKET. In 1911, Cuneo Market on Weber Avenue provided poultry and fruit as well as 16 varieties of vegetables. Prior to the establishment of sanitation laws, merchants hung poultry for sale out in front of the store. Stockton had numerous stores operated by Italian immigrants, who gravitated to Stockton finding the climate and terrain similar to that of their homeland.

HALE'S DRY GOODS STORE. The Hale Brothers owned and operated this store on the corner of Main and San Joaquin Streets from 1883 to 1915. In the city directory, the store advertised the sale of dry goods and clothing, as well as fancy goods.

H.J. KUECHLER STORE. This view is of the corner of Main Street and California Street, looking west down Main Street. On the right is the store of Henry J. Kuechler, watchmaker, jeweler, and engraver. Kuechler, a native of Switzerland, operated at this corner location since 1908. During the 1920s, F. Will Kuechler entered into business with his father creating H.J. Kuechler & Sons, a successful partnership and establishment for many years.

THE STERLING. This popular clothing store was located at the southwest corner of Hunter and Main Streets. The store opened in 1905 and remained in business until the early 1960s. Some of the text on this advertising postcard reads, "The largest Ready to Wear establishment For Women and Children. We occupy this entire building. Four floors with elevator service. Shirts, Waists, Corsets, Sweaters, Muslin Underwear, Kimonos, Petticoats, Hosiery, Knit Underwear."

F.A. Gummer Furniture Store. This unique, three-page foldout postcard provides a great panoramic view of the main floor of the Gummer Furniture Store. Opened in 1912, the store was located in a three-story building on the north side of Weber Avenue between Sutter and

MAIN FLOOR OF CALIFORNIA'S MOST BEAUTIFUL
FURNITURE STORE
F.A.GUMMER. STOCKTON.

California Streets. The store owned by Frank Gummer sold furniture as well as large variety of household items. The business closed in 1923. This detailed advertising postcard of the store is displayed with the left two panels of the postcard above and the right two panels below.

SAN JOAQUIN VALLEY BANK. In 1904, the San Joaquin Valley Bank opened this building on the west side of Hunter Square. The Valley Bank began as one of Stockton's first banking institutions, the Bours and Company, founded by T. Robinson Bours in 1852. The company reorganized to become the San Joaquin Valley Bank in 1862. The Bank of Italy, later to become Bank of America, bought the San Joaquin Valley Bank in 1917.

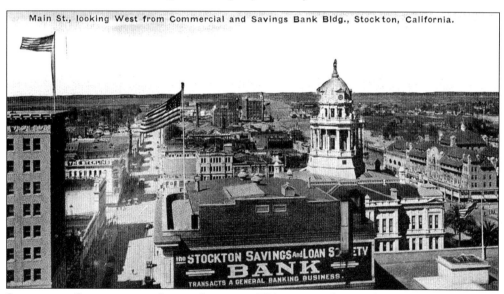

STOCKTON SAVINGS AND LOAN SOCIETY. This postcard provides a rear view of the Stockton Savings and Loan Society building looking down Main Street. The courthouse and the Hotel Stockton are on the right of the postcard. The side of the building has an example of a common marketing technique of the time, painting an advertisement for the business directly onto the building.

Stockton Savings and Loan Society. Located at San Joaquin and Main Streets, this Classical Revival–style building was completed in 1908. The eight-story building was known as the first skyscraper in Stockton. The bank, chartered in 1867, became the Bank of Stockton in 1958. This historical landmark has preserved many of its original features, including a beautiful marble lobby.

COMMERCIAL AND SAVINGS BANK. The Commercial and Savings Bank was established in 1903 and located on Main Street. In 1915, it moved to this ten-story steel-frame building of sandstone and terra cotta at the corner of Main and Sutter Streets. This advertising postcard is printed with, "Better than cash is a checking account. Better than 'an old pocket book' is a safe deposit box. Better than 'any old place' is our savings department."

Farmers and Merchants Bank

4584

FARMERS AND MERCHANTS BANK. This nine-story skyscraper was opened in 1917 at the corner of San Joaquin and Main Streets, once the site of the Rosenbaum and Crawford building. George W. Kelham, the architect credited with designing the St. Francis Hotel in San Francisco, designed this Italian Renaissance structure. In 1941, Levinson's Bridal Shop began occupying the first floor of this building until the shop closed in the early 1980s.

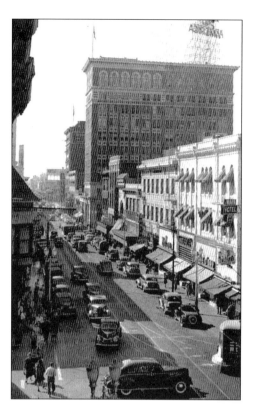

COMMERCIAL AND SAVINGS BANK. This 1940s postcard provides another view of the Commercial and Saving Bank. After a fire in 1923, the Renaissance-style building was expanded and reopened as the main branch of the Bank of America. In comparison with the previous view, one can see that the structure was doubled in size along Sutter Street. Today, this national historical landmark is used as an office building.

FARMERS AND MERCHANTS BANK. Today, this building is referred to as the California Building and serves as commercial offices. In this postcard, located next to the bank building behind the palm tree, is the T and D Theater built in 1916. The theater was eventually renamed the Fox Theater, extensively remodeled, and reopened in October 1930 to become a very popular showplace.

BELDING BUILDING. The Belding Soda Works erected this five-story building in 1915 on the northeast corner of San Joaquin Street and Weber Avenue. Prior to that time, the Yosemite Cash Grocery Store occupied the site. Conveniently located across the street from the courthouse, this Beaux Arts–style building became an office building after the soda company left.

STOCKTON RECORD. In 1895, Irving Martin started the *Stockton Record* in a basement on Parker's Alley near Hunter Street. Despite fierce competition from two other newspapers, the *Stockton Record* became the only newspaper in town by 1939. The *Stockton Evening Mail* was bought by Martin in 1917 and the *Stockton Independent* went out of business in 1939. The *Record* moved to its current Market Street location in 1910.

DAWSON'S FIREPROOF WAREHOUSE. Built in the style of an Egyptian tomb, this warehouse building featured Egyptian figures, glazed tile, and giant columns. The Dawson Van and Storage Company opened this Egyptian Revival building at 630 North California Street in 1917. This advertising postcard reads, "Storage, Moving, Packing, Shipping. Dependable service and personal supervision. Fire and burglar proof safe deposit vaults. Cedar lockers for furs."

STOCKTON WATER WORKS. The first water company in Stockton was started by P.E. Connor in 1859. After several different owners, it was acquired by the California Water Service Company in 1927. These pump stations or plants were located throughout the city to help maintain equal water pressure. Each was built and maintained to blend in with the surrounding neighborhood residences.

Six
RICH FARMS AND
BOUNTIFUL HARVEST

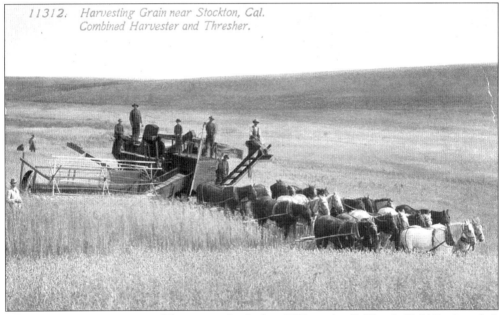

COMBINED HARVESTER AND THRESHER. In the late 1800s as the California Gold Rush ended, the agricultural land surrounding Stockton became one of the largest wheat growing areas in the country. Combined harvesters and threshers became common in wheat harvesting. This particular combine could cut, thresh, and clean grain in one process. The ability to cut and thresh at the same time was especially useful in the dry summers of the Central Valley.

11310. Harvesting Scene, San Joaquin Co. near Stockton, Cal.

HARVESTING SCENE. As early as 1890, the local Holt Manufacturing Company began developing steam traction engines to replace horse-drawn machines. With large frames, the new combines could hold more than 600 gallons of water. The use of steam power decreased the cost and the time needed for harvesting. Several different types of combines were developed by various companies, but the Holt Manufacturing Company became the leading combine manufacturer in the country.

STEAM TRACTION ENGINE. This "undivided back" postcard, postmarked in 1908, shows the back of a steam traction engine. The three six-foot-wide wheels on each side were specially built around 1903 to work on the soft peat land around Stockton. This 44-foot traction engine could plow, seed, and harrow numerous furrows at a time. This labor-saving device was expensive to build and operate, and difficult to turn around at the end of the field.

STEAM PLOWING. This postcard from the early 1910s shows another steam plowing engine. These steam engines were precursors to the development of track laying machines and the Caterpillar tractor, made famous by the Holt Manufacturing Company.

FIVE-TEAM TRAIN OF WAGONS. Mule trains were used to transport grain from the fields to the waterfront. This postcard claims, "The San Joaquin Valley, with its 7,000,000 acres of land, is the granary of the state. Acres of growing grain as far as the eye can see. This calls for the most approved and modern methods of harvesting—twenty horsepower harvesters and five team wagon trains loaded with grain are not an uncommon sight."

GRAIN WAREHOUSES. Since the 1880s, growers throughout the Central Valley brought grain to these large warehouses on the Stockton Channel to be stored and shipped. The grain was either stored in the warehouses or shipped immediately to regional and foreign markets. Before the railroads were established, grain was transported over land by wagon train or by water in shallow river barges. Notice several barges on the north side of the channel.

STORING GRAIN IN WAREHOUSES. From 1860 to 1890, Stockton was the center of the grain trade, with the San Joaquin River providing easy access from the fields to the port. With the advent of railroads and the ability to ship grain by train, Stockton's river access declined in importance. This 1910 postcard shows the grain storage in one of the many warehouses along the inland port. Each of these grain sacks held about 135 pounds of grain.

FLOUR MILLS ON WATERFRONT. The Sperry Flour Company was established in 1852 to accommodate the abundance of wheat being produced locally. The company eventually operated three mills producing cereal, flour, and animal feed. This is a nice view of the largest flour mill, which was built in 1890. The two-story building behind the mill is the "Waterfront Warehouse" and still stands today as the oldest intact building on the Stockton Channel's south shore.

INTERIOR OF FLOUR MILL. This postcard from around 1910 provides a view of the interior of a mill as flour is being bagged by workers. Flour was produced by a grinding and sifting process before being bagged. The Sperry Flour Company sewed and printed its own flour bags.

IRRIGATED VINEYARD. As early as the 1890s, the diversion of water from natural streams and rivers allowed farmers to begin growing specialty crops in addition to grain. Two methods of irrigation were common. Besides pumping water from wells, farmers could irrigate crops when the elevation of their farmland was lower than the river surface. By the early 1900s, farmers throughout the county had converted their land into vineyards and orchards.

PUMPKIN FIELD. Printing on the back of this card, postmarked in 1910, says, "San Joaquin is the Gateway county of California. It is only 12 hours by boat from the market that supplies one-half the people of this beautiful state. Can ship eggs, fruit and produce at low freight rates. Rich, deep soil sells for an average of $100 per acre and I don't have to irrigate for everything I raise."

727 – Almond Orchard in Blossom.
near Stockton, California.

ALMOND ORCHARD IN BLOSSOM. Almond trees are the first fruit or nut trees to bloom each spring. Each February, almond trees are covered with delicate pink blossoms. This card, postmarked in 1912, depicts an almond orchard near Stockton. Almonds were one of the leading agricultural industries near Stockton at that time.

LOAD OF ALMONDS. Almonds are harvested in late summer or early fall. In the early 1900s, the nuts were knocked from the trees with long poles and the hulls were stripped off by hand. The stripping was often done by women and children. The nuts were then dried in the sun and bleached with sulphur fumes to make them attractive for the markets. This postcard shows a cartful of almonds on Hunter Square.

HARVESTING FRUIT. In the early 1900s, deciduous fruits such as peaches, apricots, plums, and prunes were grown on thousands of acres of fertile land along the rivers that bisect the county to the north and west of Stockton. These profitable crops included cherries, shown here being harvested in the 1940s. Cherry trees are one of the last trees to bloom in the spring but the first to produce ripe fruit.

PICKING OLIVES. This postcard of the early 1900s shows an entire family picking olives. In 1905, the olive-growing area of San Joaquin County comprised 1,700 acres. The average yield of a ten-year-old olive tree was 250 pounds. A farmer of an 80-acre olive orchard claimed that in 1904 he manufactured 3,000 gallons of olive oil, besides picking 7,500 gallons of olives for curing.

A Sample Pumpkin and Egyptian Corn (*above*), and Cutting Cabbage (*below*). The back of these *c.* 1905 chamber of commerce postcards reads, "San Joaquin County is the most rapidly developing agricultural area in America. When it was found that the ever present snows in the mountains furnished ample water to irrigate the plains, the great ranches were cut up into small holdings and today intensive farming is the general practice. There are thousands of acres that can be irrigated and there is ample water for all. Come out this fall and investigate. The Santa Fe will sell you one-way Colonist tickets any day September 15 to October 15 for only $33 from Chicago, $32 from St. Louis, $25 from the Missouri river and relatively low fares from your home town."

ITALIAN SWISS COLONY NEAR STOCKTON. In 1881, the Italian Swiss Agricultural Colony was founded in Sonoma County as a cooperative for Italian and Swiss immigrants to grow grapes and produce wine in California. Although the company had a turbulent history, it was one of the leading wineries in the country. This postcard shows a group of men making barrels near Stockton, possibly at the company branch in Lodi, the Shewan-Jones plant.

CALIFORNIA CHICORY WORKS. This company was the largest supplier of chicory in the nation during the 1890s. It was located on the San Joaquin River, eight miles west of Stockton. Roasted and ground chicory roots were used to mix with or substitute for coffee. The person sending this postcard wrote, "This river is largely used for transporting the farming products to market in flat bottom loads. It is cheaper than the railroads."

EL PINAL WINERY. The first commercial winery in the region was established by George West in 1858. Located off West Lane near Alpine Avenue, it was famous for its wines and brandies. As shown in this postcard, the company's proximity to tracks of the Southern Pacific Railroad facilitated the transportation of grapes. Prohibition forced the winery to close in 1918. Today, the site of the winery is the El Pinal Industrial Park.

PRODUCE BARGES. This card, postmarked in 1910, shows produce-laden barges coming from fields in the Delta to the wharves of Stockton. In 1904, the chamber of commerce boasted that every farm was within two miles of a navigable waterway. Crops could be shipped by waterways or railroads throughout the state, or by transcontinental railways to other states.

HONEY GROVE DAIRY. The green pastures of the Delta land produced a mixture of grasses that provided a balanced food for cattle throughout the year. This particular dairy was operated by the Reyner Brothers on the corner of Stanislaus Street and South Street (now Charter Way) from 1896 to 1900. The milk was delivered to customers by horse and buggy.

DAIRYING SCENE. By 1950, California was one of the top milk-producing states in the country. The San Joaquin County dairy industry had grown tremendously because of the area's ideal climate, growing population, and production of high-quality alfalfa and other crops whose byproducts could be used for feed.

SHEEP IN SHADE OF POPLARS. Sheep ranchers were common in the early part of the 20th century. This postcard provides a view of a herd of sheep along the San Joaquin River.

AGRICULTURAL SCENE. This 1940s postcard illustrates a common agricultural scene near Stockton. Today, San Joaquin County remains in the top ten of agricultural counties within the state.

HAYING SCENE. The growing dairy industry in San Joaquin County required huge amounts of hay.

HARVESTING FLAX. This 1940s postcard illustrates a harvesting scene. Flax seed was used to produce vegetable oil and for food and feed supplements.

Seven

RENOWNED COLLEGES, SCHOOLS, AND HOMES

THE COLLEGE OF THE PACIFIC. This postcard shows the college soon after its completion in 1925 and without the lush landscaping it's known for today. Founded in 1851, the College of the Pacific is the state's oldest chartered institution of higher learning and is an independent college of the Methodist Church. Originally located in San Jose, the college was relocated to Stockton in 1920 by the board of trustees under the leadership of President Tully C. Knoles.

SMITH GATE, COLLEGE OF THE PACIFIC. Smith Memorial Gate was named for Harriet M. Smith, the mother of J.C. Smith who donated the original 40 acres of the college. The gate was originally located on the east side of campus near where Burn's Tower is today. This card says, "Smith Memorial Gate leading onto a beautifully landscaped 74-acre campus. Seventeen Gothic Style brick buildings and a large stadium now form California's oldest institution in Stockton."

CONSERVATORY, COLLEGE OF THE PACIFIC. This building was considered the finest of the first ten college buildings constructed in the early 1920s.

MUSIC CONSERVATORY, COLLEGE OF THE PACIFIC. The Conservatory of Music building opened in 1927 and was the first accredited professional school of music in the western United States. Later renamed for Faye Spanos, the concert hall is still a popular site for musical performances, including operas, choruses, jazz, percussion, string and brass ensembles, symphonies, and recitals.

MORRIS CHAPEL, COLLEGE OF THE PACIFIC. In 1942, this chapel was dedicated as a place of worship on the campus of the College of the Pacific. The medieval building is a popular venue for weddings. The printing on the back of the card reads, "With its stained glass window, artistic hand carved oak furnishings, the everlasting light over the chancel, the chaste case-stone altar and the Kress Aeolian organ."

EPSILON LAMBDA SIGMA. Fraternity life has been an important part of the college history. Several fraternities and sororities are located on and off campus. The Epsilon Lamda Sigma sorority house was built on the campus grounds in 1925. The sorority became Delta Gamma in 1959.

COLLEGE OF THE PACIFIC, AERIAL. This advertising postcard for the college says, "Aerial view of the College of the Pacific, Stockton, California, showing Baxter Stadium, gymnasium, Fraternity and Sorority Circles, the Conservatory of Music and the Greek Theatre. One of California's most beautiful colleges, this campus was once a deserted field until landscaped by depression burdened students."

COLLEGE OF THE PACIFIC. Another promotional postcard for the school reads, "Besides the Calaveras River lies College of the Pacific, possessor of one of America's most beautiful college campuses and the oldest chartered college in California. In the foreground is the 36,000 seat 'Lair of the Tigers' Pacific Memorial Stadium."

MAIN BUILDING, STOCKTON HIGH SCHOOL. The domed main building was the first structure of the Stockton High School campus built in 1904 at the corner of California and Vine Streets. The Anglo Classic–style building, designed by local architect George Rushforth, held 24 classrooms.

STOCKTON HIGH SCHOOL. A growing student population required continuous construction and renovation on the ten-acre campus. A science building, gymnasium, and swimming pool were built behind the main building in 1914. The grounds included expanses of lawn and flowerbeds, as well as a greenhouse and botanical garden. A 2,400-seat auditorium was completed in 1922 and still stands today.

STUDENTS AT STOCKTON HIGH SCHOOL. This is a view of the school from California Street with students on the playing fields. The domed building on the left is the main building with the one-story gymnasium in the center and the science building located on the right.

MAIN BUILDING, STOCKTON HIGH SCHOOL. This 1940s postcard shows the main building, which was condemned in 1966 and demolished in 1967. The card says, "This is one of several buildings on the large campus, which houses over 3,000 students." Because Stockton High was the only high school in town until 1942, many in the community mourned the demolition of its oldest building.

WEBER GRAMMAR SCHOOL. Built in 1912 on the corner of Church and American Streets, the school was named after Capt. Charles Weber. It was renamed Lafayette when a new school on Madison Street was named for Weber. This French Renaissance building with nine classrooms and two halls closed in 1972. The site where it was located became Gleason Park.

WASHINGTON STREET SCHOOL. This postcard shows Washington School after the removal of its third floor. The school opened in 1870 as a two-story building at San Joaquin and Lindsay Streets. A third floor was added in 1891 to accommodate a growing student population. Used for only four years, the third floor came to be seen as a potential fire hazard and was removed in 1911. The Bank of Stockton is now located on the site.

NORTH SCHOOL. North School was built in 1912 and later named Woodrow Wilson Grammar School. The school at Mariposa and Hunter Streets was originally part of the rural North School District. The two-story building of brick and plaster included four classrooms with an assembly hall. As the city grew, several additions were made to the school, including eight classrooms in 1922.

LOTTIE GRUNSKY GRAMMAR SCHOOL. This card shows the school at the time of its opening in 1919 on North Street (now Harding Way) and East Street (now Wilson Way). Named after a Stockton school teacher, the two-story Colonial-style school had four classrooms on each floor. The school and grounds were extensively renovated after World War II. The building was torn down in 1977 and an earthquake-resistant school was constructed on the site.

THE "OLD" EL DORADO SCHOOL. These postcards show El Dorado School, which was built in 1898 at the corner of El Dorado and Vine Streets. The three-story wooden building had eight classrooms, a full basement, and an assembly hall for 500 students. Viewed as an example of a modern facility by other districts, this was the first Stockton school with indoor lavatories and central heating. Although schools were usually named after prominent individuals, this school was named for the street it faced. The school was abandoned in 1918 and the land was later sold to the First Presbyterian Church.

Eldorado School, STOCKTON, Cal.

THE "NEW" EL DORADO SCHOOL. The "new" El Dorado School was built at the corner of North Street (now Harding Way) and Lower Sacramento Road (now Pacific Avenue). This school was built to replace the "old" El Dorado School on El Dorado and Vine Streets. This ten-acre site was purchased in 1914 and the school opened in 1916. This card was postmarked in 1920.

ARCHITECTURE, "NEW" EL DORADO SCHOOL. The school is a prime example of Elizabethan Tudor architecture and is now preserved as a local and national registered landmark. This photo postcard, sent in 1942 by a private from Squadron A at Camp Stockton, says, "I like it here in California but it gets cold at night. In the daytime it is warm. We walk in it. It's a big city."

BERACHAN HOME FOR GIRLS. This home for both single women and women with children operated in Stockton from 1912 to 1915. Located at the northeast corner of San Joaquin and Clay Streets, the home offered quality, affordable housing and employment preparation services for underprivileged women. The home was operated by the Volunteers of America, a nonprofit organization serving the poor.

ST. AGNES ACADEMY. The postcard shows the St. Agnes Academy graduating class of 1911. Established in 1876 on Taylor Street, the parochial school reopened in 1914 on San Joaquin Street between Park and Oak Streets and taught girls from first through twelfth grades. Boys were admitted to the school in 1918. An adjoining building, the St. Agnes Convent, was built in 1920 to house nuns who operated the school. (Courtesy of the San Joaquin County Historical Society and Museum.)

WESTERN SCHOOL OF COMMERCE. The Western School of Commerce, located at San Joaquin and Channel Streets, taught shorthand and other business skills. It began in 1901 when it took over another school, the Gas City Business College. Western School of Commerce had 3 teachers and 40 pupils in its first year. This postcard shows students posing in front of the school.

HEALD'S BUSINESS COLLEGE. Heald's mission was to prepare students for business careers and focused on practical, hands-on learning. This 1950s postcard shows a large class of students in the bookkeeping department. The postcard reads, "We invite you to Stockton to Heald's Business College, the best school for a thorough training in bookkeeping and shorthand."

Heald's Business College, Stockton, Cal.

HEALD'S BUSINESS COLLEGE. In 1909, the commercial department of the Western School of Commerce was sold to Heald's Business College. This postcard, postmarked in 1911, shows students in front of the building at San Joaquin and Channel Streets occupied by Heald's Business College. In 1920, Western School of Commerce merged with Heald's to become the Stockton College of Commerce. Many of Stockton's business and professional leaders received training at this institution.

F. N. Vail's Residence, Stockton, Calif.

F.N. VAIL'S RESIDENCE. Many elaborate homes were built during Stockton's golden era at the beginning of the century. This house was located on the southwest corner of Rose and Monroe Streets. Outstanding features of the Vail residence included a half-beam cathedral-like drawing room, picture windows looking out onto a formal garden, a mezzanine floor with a billiard table, and an indoor pool. This residence no longer exists.

The Hillman Residence, Stockton, Calif.

THE HILLMAN RESIDENCE. This mansion on the southwest corner of Harding Way and El Dorado Street was built in 1905 by Frank Hillman, a farm land developer. The home included a sunken Roman bath, a ballroom on the third floor, and a broad porch encircling the second floor. The grounds were surrounded by a brick retaining wall and boxwood hedges. The house was later owned for many years by Fred Rindge, another land developer.

"A STOCKTON RESIDENCE." The Magnolia Historic Preservation District was organized in the 1970s in an effort to preserve historic homes in a residential area of central Stockton south of Harding Way and north of Park Street. Many of the residences date to the late 1800s and were built in the architectural styles of Queen Anne, Victorian, Craftsman, and California Bungalow. This 1908 Craftsman-style house still stands on Magnolia at Hunter Streets.

APARTMENT HOUSES. Before the advent of apartment houses, people who did not have private homes resided in hotels and rooming houses. In 1925, the city listed 61 apartment houses, an increase from the 19 apartment houses listed a decade earlier. The Home Builder and Security Company leased apartments from 1912 to 1917 at this building at El Dorado and Flora Streets, now referred to as the Mayfair Apartments.

Eight
NOTABLE HOSPITALS
AND CHURCHES

STOCKTON EMERGENCY HOSPITAL. Built in 1905, this emergency hospital included an operating and sterilization room and was open to receive patients around the clock. Located on San Joaquin Street between Channel and Miner Streets, it was endowed to the community by the Hough family in memory of Henry Harper Hewlett. In 1917, the family also donated a dental room in memory of their son. It is now a county office building.

ST. JOSEPH'S HOME AND HOSPITAL. Originally planned as a rest home for elderly men, the facility was founded in 1899 by Fr. W.B. O'Conner, pastor of St. Mary's Church. Local physicians encouraged O'Connor to include a hospital in his plans for the ten-acre site at California and Walnut Streets. After extensive fundraising, the home and hospital opened in December 1899. This postcard shows the new building after its completion in 1905.

ST. JOSEPH'S HOME AND HOSPITAL. The oldest private hospital in Stockton, St. Joseph's was managed by the Dominican sisters. Father O'Connor, the hospital founder, died in 1911 and a bronze statue of him was erected on the grounds in 1914. A school of nursing was operated by St. Joseph's from 1905 to 1938. Today, it is the largest regional medical center in the county.

SAN JOAQUIN COUNTY HOSPITAL. This postcard shows the second county hospital that was built in French Camp in 1895. The first county hospital was built at Wilson Street and Hazelton Avenue in Stockton in 1857, but was destroyed by a fire in 1892. This building, with a three-story cupola in the center and two hexagonal structures on each side, was used for admitting and receiving patients while the adjoining structures were used as wards.

SAN JOAQUIN COUNTY GENERAL HOSPITAL. In 1932, a more modern hospital structure of brick buildings replaced the wooden structures. A second brick wing was completed in 1943. Notice the original administration building on the left of the postcard. The printing on the back of this postcard states, "Said to be one of the finest county hospitals in America, this modern hospital serves San Joaquin County and is located near Stockton, California."

MALE DEPARTMENT, STATE HOSPITAL. The earliest public psychiatric facility for the mentally ill in the West, the Insane Asylum of California was built on 100 acres of land on California Street donated by Capt. Charles Weber. Begun in 1852, the asylum added a new building or wing every year until 1857. This 1908 postcard shows the Male Department. Built in 1875, this building was partially destroyed by fire in 1938 and was replaced in 1949.

FEMALE DEPARTMENT, STATE HOSPITAL. This 1909 postcard shows the building used to house women. In the 1930s, the Insane Asylum of California was renamed the Stockton State Hospital. In 1904, the hospital purchased more than 1,000 acres of land on Lower Sacramento Road to build a state farm. This property, the current site of San Joaquin Delta College, allowed the hospital to relieve overcrowding and provide patients with agricultural activities. In 1953, the hospital's population was 4,600.

SUPERINTENDENT'S HOME, STATE HOSPITAL. The Southern-style mansion was built in 1900 on the state hospital grounds at California and Acacia Streets. It served as the superintendent's residence until 1975. Landscaped grounds surrounded this spacious house with its distinguished columns. Dr. Margaret Smythe, the first woman to serve as superintendent of a mental hospital in the county, resided here from 1929 to 1946.

RED CROSS TUBERCULOSIS CAMP. In 1909, the San Joaquin County Chapter of the Red Cross, under the direction of Dr. Minerva Goodman, opened a 20-bed tuberculosis camp funded by the sale of Christmas Seals. Until the 1940s the only treatment for tuberculosis was rest, good nutrition, and the clean air provided in rural areas. This camp, located at Madison Street and the French Camp Turnpike, was used for three years before being destroyed by fire.

St. Mary's Church
Stockton, Cal.

ST. MARY'S CHURCH. Two priests on their way to the mines held the first Catholic service in Stockton in 1849 at Capt. Charles Weber's home. Weber donated land at Washington and Hunter Streets for a local church in 1851. The first church was a wooden structure with room for 150 parishioners. In 1861, the original "Gold Rush" church was replaced with this building, St. Mary's of Assumption.

ST. MARY'S CHURCH. This Catholic church is the oldest non-residential building in Stockton and the third oldest church in Central California. The house to the left of the church in this early 1920 postcard is the rectory, the residence of the parish priest.

ST. MARY'S. This church was built in sections as resources became available. The nave and square bell tower were built in 1861. The transept was added in 1869 and the pipe organ in 1881. The Gothic spire, façade, and stained-glass windows were added in 1893. The building was further remodeled between 1945 and 1949.

CATHEDRAL OF THE ANNUNCIATION. Stockton's third Catholic church was built in modified Gothic style at the corner of Rose and Van Buren Streets in 1942. It was intended to replace the "old" St. Mary's Church on Washington Street. When parishioners of the "old" St. Mary's objected to its destruction, the "old" church was spared and this "new" church was renamed Church of the Annunciation, later Cathedral of the Annunciation.

11786. Grace M. E. Church, Stockton, Cal.

GRACE METHODIST EPISCOPAL CHURCH. The building of this church on Channel and Stanislaus Streets began in 1909 and was near completion when a fire burned it down. The church was rebuilt from the same plans, with the exception of the stucco facing. The building had a boxy appearance with a tall pillared entrance. There was no belfry or steeple as was common for churches at the time. The church was dedicated in March of 1910.

CENTRAL METHODIST CHURCH. The first Methodist service was held in 1849, making it one of the first pioneer churches of Stockton. Their first church building, on Commerce and Washington Streets, dates back to 1851. This brick and sandstone church was completed in 1891 on the corner of Miner Avenue and San Joaquin Street. In 1958, the building was sold to the Bank of Stockton. The beautiful stained-glass windows are now in the new church on Pacific Avenue and Fulton Street across from College of the Pacific.

ST. JOHN'S EPISCOPAL CHURCH. This 1908 postcard shows one of the oldest church buildings in the city, dating to 1892. Located at the corner of El Dorado and Miner Streets, it was designed by San Francisco architect Ernest A. Coxhead in a cruciform shape. The building contains an organ and stained-glass window from the first church built on the same site in 1858 on land donated by Capt. Charles Weber.

FIRST PRESBYTERIAN CHURCH. The first Protestant church building in Stockton was the Presbyterian Church at Main and San Joaquin Streets, built on land donated by Capt. Charles Weber in 1850. This postcard shows the third Presbyterian church, completed in 1923 at El Dorado and Vine Streets. Printing on the card reads, "This church represents one of the most beautiful Gothic structures in Northern California. It has many features by Bertram Grosvenor Goodhue, famous designer of churches."

CONGREGATIONAL CHURCH. The church organized in 1865 and constructed their first building in 1868 on Miner Avenue between Sutter and San Joaquin Streets. This postcard shows the second church built at the northeast corner of Hunter and Park Streets in 1910. This two-story concrete building included an auditorium, school facilities, and office space. The church today occupies a building completed in 1940 on Willow and Madison Streets.

FIRST BAPTIST CHURCH. The first Baptist services in Stockton were held in 1853 in a wooden school house at Market and San Joaquin Streets. In 1860, a church was built at the corner of Hunter and Lindsay Streets. The church had a 130-foot-tall steeple with a gilded hand pointing to the sky. This postcard sent in 1919 shows the second church building, constructed in 1909. The old building was retained after the steeple was torn down.

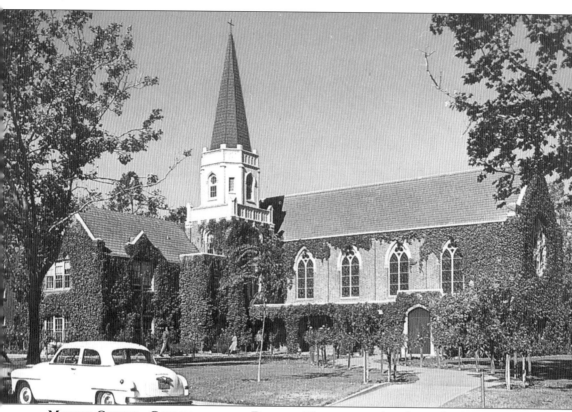

MORRIS CHAPEL, COLLEGE OF THE PACIFIC. The campus chapel was funded by a gift of Percy and Millie Morris and, in 1942, was dedicated to serve students of all faiths. The stained glass of the sanctuary and rose windows, donated by the Temple Methodist Church, and the building's architecture provide the elements of a medieval church.

Nine
FAMED MINERAL BATHS, PARKS, AND RECREATION

STOCKTON MINERAL BATHS WITH SLIDES. Built in 1893 and formerly known as the Jackson Natural Gas Well Baths, these popular mineral baths were located at the south end of San Joaquin Street, where McKinley Park is today. This card shows one of several water slides, two Venetian bridges with built in waterfalls located at either side of the circular pool, and an illuminated four-story lighthouse built in 1918.

Bath House, Stockton, California. 2102

STOCKTON MINERAL BATHS. This card, postmarked in 1912, depicts one of the 12 private bath houses at the Stockton Mineral Baths. The sign says, "Anyone using the Baths or Apparatus. Do so at your own risk." Three artesian wells provided the baths with a million gallons of water a day at a temperature between 75 to 85 degrees. Since the water contained iron, sulphur, salt, magnesium, and soda, the baths were considered beneficial for rheumatic complaints.

Hot Mineral Baths, STOCKTON, Cal.

EQUIPMENT AND DRESSING ROOMS, STOCKTON MINERAL BATHS. The pool equipment on the right has two slides, including one with a bump in the middle. Also, notice people sitting and standing on the top of the dressing rooms on the right. At the time, bathing attire for men included sleeveless shirts with tight knitted pants covered by a short skirt. Women wore blouses, bloomers covered by a knee-length skirt, stockings, and a cap.

118

HIGH DIVE, STOCKTON MINERAL BATHS. The baths included 1 main pool, 2 smaller pools, 12 private bath houses, and 150 dressing rooms. This picture of the baths shows a person standing on top of the high dive on the right. On the left, a swing drops swimmers into the pool. The baths were bought by the city in 1920 and remained popular through the 1930s. Today the site is occupied by McKinley Park and Pool.

SHADY SPOT, STOCKTON MINERAL BATHS. Besides the pools, the facility also had a club house, merry-go-round, barbecue pits, picnic tables, and tennis courts, making it a popular recreational area in the 1920s and 1930s. Many band concerts were also held at the baths. In 1920, the Independence Day festivities included a full day of entertainment with music, aquatic shows, and fireworks. Notice the top of the extra-tall high dive in the background.

119

"THE EAGLE NEST" AT OAK PARK. This card, postmarked in 1930, shows a unique swing and tree house at Oak Park on Alpine Street. Filled with valley oak trees, the 30-acre park was a very popular picnic place and drew visitors from across the state. Amenities included a bowling alley, dance pavilion, clubhouse, and playground. In 1918, the city bought the park from the Stockton Electric Railroad. Before 1902, Oak Park was called Goodwater Grove.

120

EL DORADO STREET TROLLEY. Electric street car lines spread across Stockton from the central business district to the city parks including Victory Park, Oak Park, and McKinley Park. This street car is traveling north on El Dorado Street to Oak Park. The structure that housed these electric street cars was located on California Street and is a historical landmark today. Stockton's electric street cars were replaced by buses in 1941.

YMCA BUILDING. In 1909, the YMCA moved into this building at Channel and San Joaquin Streets from their former location at 327 East Weber Avenue. It remained their headquarters until the late 1950s. Basketball was a favorite activity at both locations. In 1921, the organization opened a summer camp in Dorrington near Big Trees. On the left of the postcard is the Pacific Telephone and Telegraph Company located across the street from the YMCA.

INDEPENDENCE SQUARE. Capt. Charles Weber designated 13 plots of land as recreational areas when he donated land to the city in 1850. These city parks were once called village or public squares. Eventually, four more parks were designated by the city. Independence Square, located at Market and Aurora Streets, was used as a baseball and circus ground in the early 1900s.

HUNTER SQUARE. In designing the city of Stockton, Capt. Charles Weber included Hunter Square, a large plaza next to the courthouse. Considered the heart of the city, Hunter Square was used for farmer markets, public meetings, political rallies, festivals, and county fairs. The balcony on the courthouse dome provided a beautiful view of the plaza and horizon. The Hotel Stockton can be seen in the center of the postcard.

FREMONT PARK. The site of a 1909 monument to California pioneers, this park was named for Capt. John Charles Fremont, a famous topographer, explorer, and politician of the 1800s. Bounded by San Joaquin, Lindsay, Fremont, and Sutter Streets, this park is situated across from the post office.

PIONEER MONUMENT. The granite drinking fountain in the center of Fremont Park was dedicated on July 5, 1909 by the Women's Auxiliary of San Joaquin Sons of Pioneers.

CONSTITUTION PARK. Constitution Park at Fremont and Pilgrim Streets was a favorite place for camping in the early 1900s because of its many oak trees. Many of the streets and public squares named by Capt. Charles Weber have patriotic and military significance.

PALM DRIVE. The Stockton State Hospital, formerly the Insane Asylum of California, was located on over a hundred acres along California Street. These beautiful grounds were landscaped and maintained by the residents. This is a view of Palm Drive, which passed in the front of the superintendent's house.

WASHINGTON PARK. This park was located across from St. Mary's Church on Washington Street until 1977. In 1888, the San Joaquin Agricultural Society Pavilion occupied this entire block. The pavilion was Stockton's largest building and the location of many agricultural fairs. The building was destroyed by a fire in 1902 and its site became Washington Park. Today, the site is covered by the cross-town freeway.

VICTORY PARK. In 1916, the Philomathean Club chose the name Bienvenido, meaning "welcome," for the 27-acres on Pershing Avenue dedicated by the city as a park. In 1921 the park on Pershing Avenue was renamed Victory Park for World War I. The printing on the back of the 1950s postcard says, "Providing picnic facilities, kiddie swings, swim pool, tennis courts, softball, flag football, Haggin Memorial Museum and little league baseball."

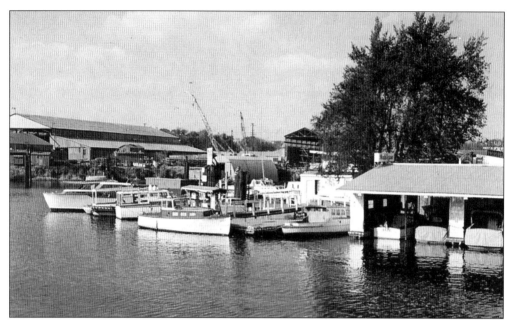

YACHT AND HARBOR. The back of the postcard reads, "The Uptown Yacht Harbor, one of several near the head of the channel. With over 1,000 miles of waterways this is a veritable paradise for the pleasure boat owner. Fishing and hunting are a pleasure as the Delta waters are always calm and many interesting trips can be made without covering the same area over again."

BOATING ON SAN JOAQUIN RIVER. This card, postmarked in 1946, illustrates the recreational activities of the San Joaquin River and California Delta that surround the city. Sailing, waterskiing, houseboating, fishing, and dining on the Delta attract many visitors to Stockton. Today, the area in and around Stockton has more marinas and yacht clubs than any other part of the Delta.

BIBLIOGRAPHY

Bonta, Robert E. and Horace A. Spencer. *Stockton's Historic Public Schools*. Stockton: Stockton Unified School District, 1981.

Davis, Olive. *Slow, Tired and Easy Railroad: The Story of the Stockton Terminal and Eastern Railroad and its Rough Road to Success*. Fresno, CA: Valley Publishers, 1976.

Davis, Olive. *Stockton: Sunrise Port on the San Joaquin*. Woodland Hills, CA: Windsor Publications, 1984.

Hardeman, Nicholas P. *Harbor of the Heartlands: A History of the Inland Seaport of Stockton, California from the Gold Rush to 1895*. Stockton: The Holt-Atherton Pacific Center for Western Studies, University of the Pacific, 1986.

Kennedy, Glenn A. *It Happened in Stockton 1900–1925, Volume I–III*. Stockton: Private Printing, 1967.

Payne, Walter A. (ed). *Benjamin Holt: The Story of the Caterpillar Tractor*. Stockton: The Holt-Atherton Pacific Center for Western Studies, University of the Pacific, 1982.

Spencer, Horace A. *Railroads of San Joaquin County: An Elementary School Source Book*. Stockton: San Joaquin County Superintendent of Schools, 1976.

Tinkham, George H. *History of San Joaquin County, California, with Biographical Sketches*. Los Angeles: Historic Record Company, 1923.

Union Safe Deposit. *Stockton Historical Landmarks*. Raymond W. Hillman (ed). Stockton: Mills Press, 1976.

Wik, Reynold M. *Benjamin Holt and Caterpillar: Tracks and Combines*. St. Joseph, MI: American Society of Agricultural Engineers, 1984.

Wood, Coke R. and Leonard Covello. *Stockton Memories: A Pictorial History of Stockton, California*. Fresno, CA: Valley Publishers, 1977.

Index

Agricultural Pavilion, 6
Argonaut Hotel, 29
Belding Building, 73
Berachan Home for Girls, 100
California Chicory Works, 84
Cathedral of the Annunciation, 112
Central California Traction
 Company, 20
Central Methodist Church, 113
City Hall, 40
Civic Center, 39
Civic Memorial Auditorium, 41
College of the Pacific, 89–93
Commercial and Savings Bank, 70,
 72
Congregational Church, 115
Constitution Park, 124
Cuneo Market, 64
courthouse, 33–37
Dawson's Fireproof Warehouse, 74
El Dorado School, 98, 99
El Dorado Street, 56, 121
El Pinal Winery, 85
Elks Building, 45
Farmers and Merchants Bank, 71, 72
First Baptist Church, 115
First Presbyterian Church, 114
Fremont Park, 123
Grace Methodist Episcopal Church,
 112
Gummer F.A. Furniture Store, 66,
 67
Haggin Museum, 44
Hale's Dry Goods Store, 64
Hazelton Library, 43
Heald's Business College, 101
Hillman Residence, 103
Holt Manufacturing Company, 61,
 76
Honey Grove Dairy, 86
Hotel Arlington, 29

Hotel Arlington Cafeteria, 31
Hotel Clark, 26
Hotel St. Leo, 30
Hotel Stockton, 21–25
Hotel Wolf, 28
Hubbard Building, 54
Hunter Square, 122
Imperial Hotel, 27
Independence Square, 122
Italian Swiss Agricultural Colony, 84
jail, 38
Kuechler, H.J., 65
Lincoln Hotel, 30
Lonjers Café, 31
Lottie Grunsky Grammar School, 97
Main Street, 47–51
Market Street, 55
McLeod Lake, 13
Mineral Baths, 117–119
Morris Chapel, 92, 116
North School, 97
Oak Park, 120
Odd Fellows Hall, 46
Pacific Avenue, 57
Pacific Window Glass Company, 60
Palm Avenue, 56, 124
Peters, J.D., 16
Philomathean Club, 45
Pioneer Monument, 123
Port of Stockton, 62, 63
post office, 42
Red Cross Tuberculosis Camp, 109
San Joaquin County General
 Hospital, 107
San Joaquin Street, 54
San Joaquin Valley Bank, 68
Santa Fe Depo, 17
Southern Pacific Depot, 18
Southern Pacific Motor Cars, 20
Sperry Flour Company, 79
St. Agnes Academy, 100

St. John's Episcopal Church, 114
St. Joseph's Home and Hospital,
 106, 107
St. Mary's Church, 110, 111
state hospital, 108, 109
Sterling, 65
Stockton Emergency Hospital, 105
Stockton Fire Department, 43
Stockton High School, 93–95
Stockton Record, 73
Stockton Savings and Loan Society,
 68, 69
Stockton Terminal and Eastern
 Railroad, 19
Stockton Water Works, 74
Sutter Street, 55
Vail, F.N. Residence, 103
Victory Park, 125
Washington Park, 125
Washington School, 96
Walker, T.C., 16
Weber Avenue, 52, 53
Weber Grammar School, 96
Western Pacific Depot, 19
Western School of Commerce, 101
YMCA Building, 121
Ye Olde Hoosier Inn, 32
Yosemite Theatre, 54